ABOUT THE AUTHOR

CLARK COUNT

Sue Pruett, MDA, was introduced to decorative painting over twenty-five years ago when she took a tole painting class. The self-described "worst student in the group," Sue says it was persistence and great desire that kept her painting. Never did she dream that she would one day enjoy what she now calls a "career and a half" in the decorative arts.

Certified by the Society of Decorative Painters as a Master Decorative Artist, Sue teaches her craft all over the country and in Japan, designs her own patterns, and authors instructive books and magazine articles on decorative painting. She shares an Oceanside, California, home with her husband and daughters, and paints and designs in her nearby second home, "Sue's Decorative Art Studio."

ACKNOWLEDGMENTS

Thank you to my many friends for encouraging me to never give up. Thank you Pat Eisenbraun and Lorraine Perkins for your never-ending help and encouragement. To my favorite teachers, Ann Kingslan, Cheri Rol and Peggy Stogdill, you are an inspiration to me, and I'll never forget your friendship. Thank you, Banar Designs, for your patience with me.

DEDICATION

I would like to dedicate this book to my awesome family and friends, whose unconditional love and support will never be taken for granted. Thank you, Chris, my husband of 19 years, for your cooking, grocery shopping, and patience with me, and for being "Mr. Mom." To Kristina, my 16-year-old, who has always shared my passion to become an artist. To Nicole, my 14-year-old daughter, who would want me by her side twenty-four hours a day if it were possible. Thank you for understanding why I can't always be there. To my mom and sister, Connie, for understanding why I can't be there when they need me most.

Pretty Painted Flowers. Copyright © 2003 by Sue Pruett. Printed in Singapore. All rights reserved. The patterns and drawings in the book are for personal use of the crafter. By permission of the author and publisher, they may be either hand-traced or photocopied to make single copies, but under no circumstances may they be resold or republished. It is permissible for the purchaser to make the projects contained herein and sell them at fairs, bazaars and craft shows. No other part of this book may be reproduced in any form or by any electronic or mechanical means including information storage and retrieval systems without permission in writing from the publisher, except by a reviewer, who may quote a brief passage in review. Published by North Light Books, an imprint of F&W Publications, Inc., 4700 East Galbraith Road, Cincinnati, Ohio 45236. (800) 289-0963. First edition.

07 06 05 04 03 5 4 3 2 1

ISBN 1-58180-461-X

1

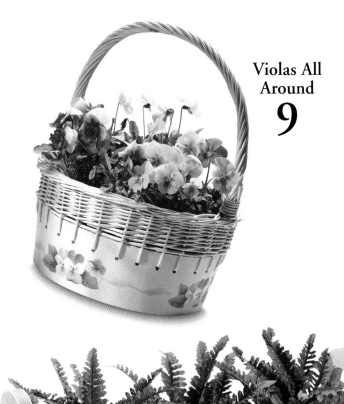

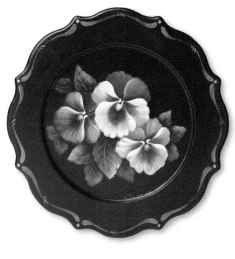

CONTENTS

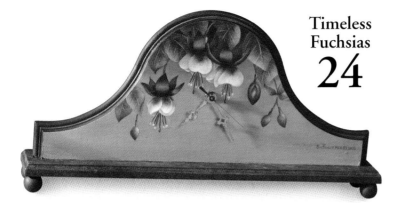

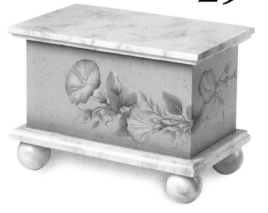

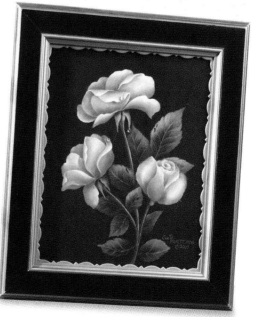

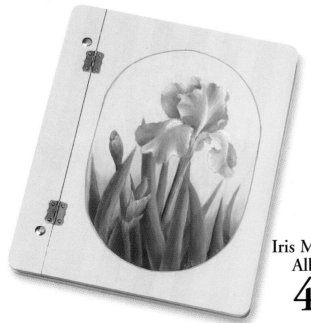

SUE'S SUPPLY LIST

Brushes - Royal & Langnickel Majestic Series

no. 1 liner, R4595
no. 10/0 liner R4585
no. 5/0 script liner R4585
no. 10/0 script liner
 R4585
no. 6 filbert, R4170
no. 8 filbert, R4170
no. 4 round, R4250

no. 6 shader, R4150
no. 8 shader, R4150
no. 10 shader, R4150
no. 12 shader, R4150
½-inch (12mm) angle 206A
½-inch (12mm) wash, RA700
1-inch (25mm) wash, RA700

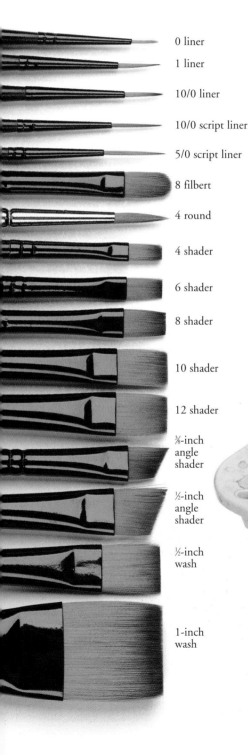

0 liner
1 liner
10/0 liner
10/0 script liner
5/0 script liner
8 filbert
4 round
4 shader
6 shader
8 shader
10 shader
12 shader
⅜-inch angle shader
½-inch angle shader
½-inch wash
1-inch wash

Paint

I used Delta Ceramcoat acrylics for all of the projects in this book. Delta has a wide variety of colors that have a rich, creamy consistency and offer great coverage.

Paint Mediums

I like Color Float by Delta for blending, shading and linework. I use Delta Gel Blending Medium for extending the drying time of paint. Follow the manufacturer's instructions for using them.

Varnish

To protect the piece after it's finished, I use varnish from Delta. I usually apply several coats of varnish, letting each coat dry between applications. You can select either a matte, satin or glossy varnish depending on the finish you prefer.

Stylus

A stylus is the tool used for applying your traced design to your piece. Most have two points, one on either end.

Eraser

I use the Magic Rub eraser for removing graphite lines.

Cotton Swabs

To clean up mistakes, use cotton swabs. With just a touch of water on the end of the swab, almost any error can be removed.

Marking Pen

For best results, when tracing your pattern on acetate, use a Sharpie marker with an extra fine point (35000). It doesn't smear as other permanent pens do.

Wet Palette

I use a Masterson Sta-Wet Palette (857) and Sta-Wet Palette Film (857).

Palette Knife

The P-12 palette knife from Royal & Langnickel is my personal favorite. It's great for mixing paints and also to transfer paints from one area to another on my palette.

Sandpaper

Most wood pieces need to be sanded before you paint them. I prefer a fine grit or very fine grit sandpaper.

Brush Basin

I always use two wash basins when I work. One is for cleaning the brush and the other one is filled with clean water for wetting the brush.

Other Supplies

Delta All-Purpose Sealer
¾" (1.9 cm) transparent tape
Blue shop towels (from auto parts stores or departments)
Chalk pencil or pencil
Clear acetate
Matches
Old knife and candle for smoking technique
Old toothbrush for spattering
Pencil and sharpener
Tracing paper
T-square ruler
Water spray bottle
Graphite paper, white and gray
Low-tack tape
Hazelnut latté
Chocolate bar

BRUSHSTROKES

Side Loading

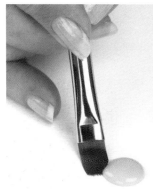

1. Dampen brush in water. Blot excess. Dip one corner of brush in paint.

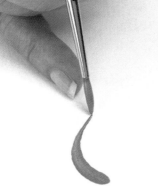

2. Blend brush a few times on palette. Paint will spread across brush, fading to clear water on opposite side.

Double Loading

1. Dip flat brush in water, blot, touch one corner of brush in paint. Turn over and touch opposite corner in another color.

2. Stroke brush on palette to blend colors at center of brush. Pure colors will remain on each corner.

Comma Stroke

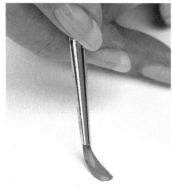

1. Touch tip of loaded round or filbert brush down and apply pressure until bristles fan out.

2. Pull brush toward you as you begin to lift to the point (curving as you pull). End on tip of brush to create thin tail of stroke.

Slip-Slap

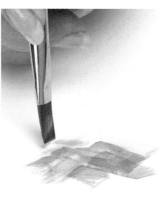

1. Using a flat brush, make loose x's in a slip-slap motion, filling in a desired area.

2. Continue slip-slapping over the top of the previous x's to build up light and dark areas. Use this technique to make interesting backgrounds.

Sideloaded Float

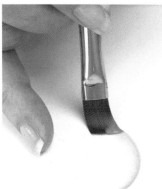

Dip flat brush in water, then side load with paint. Blend on palette. Use for subtle shading or background areas.

Chisel

1. Set chisel edge of brush on surface, holding handle straight up and down. Stroke from side to side creating straight lines.

S-Stroke

1. Using either a flat shader or a liner of your choice, load brush (flatten liner while loading). Start on the chisel at a 45° angle.

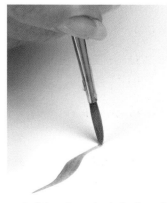

2. Pull brush to the left, then flatten to the right and lift to a chisel edge to the left. S-strokes should start and end at 45° angles.

BRUSHSTROKES

C-Stroke

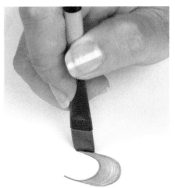

Fully load a flat shader. Starting with the brush in a horizontal position, paint a "C." Do not let the brush twist between your fingers. The stroke should go from thin to thick to thin.

Stippling

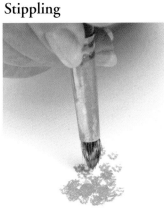

Using an old scruffy (this is a short round) or liner brush, load with paint and pounce straight up and down on surface.

Line work

Load a liner brush with paint thinned to the consistency of ink. Keep brush on its tip as you paint. Loosely balance on little finger, using long, loose strokes.

Flip Float

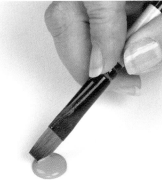

1. A flip float is used to shade or highlight the middle area of an object. Dampen the brush in water. Blot excess. Dip one corner of the brush in paint.

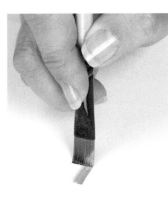

2. Blend the brush a few times on the palette. Stroke on the desired area.

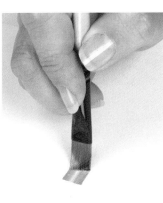

3. Flip the brush over and apply another side-load stroke, back-to-back against the previous stroke.

PAINT MIXING

Paint mixing ratio: Whenever a mix of two or more colors is required, the ratio follows as 1:1, 2:1, etc.

Palette mixing: Where large amounts of paint are desired, use the palette knife to mix the color.

Brush-mixing: This is mixing two colors together with the brush rather than the palette knife. Use where only very small amounts of paint are needed. To brush-mix a color, pick up a color and blend it into the brush, then pick up a second color and blend it together with the first.

Dirty brush mixing: Add a new color to a brush that was previously used and not washed off.

Transparent mixing: Add a little more water to paint than normal. Use this method when you want just a hint of color, or to "layer" or "pyramid" (see page 8).

GENERAL INSTRUCTIONS & DEFINITIONS

Preparing wood: Sand the wood with the grain until it's smooth. Use a very fine grit sandpaper. To get out stubborn grooves, sand in a circular motion. Dust with a towel. Seal the wood with Delta All-Purpose Sealer following the manufacturer's instructions. Once dry, the sealer will raise the grain; therefore, sand again lightly and dust.

Transferring the design: Using a sharp pencil, trace the pattern onto tracing paper. Tape the tracing onto the prepared surface. Place the graphite paper under the tracing. With a pencil or stylus, use light pressure to transfer the tracing.

Loading paints: When loading paint into the brush, pick up a small amount and work it into both sides of the brush, blending back and forth on the palette until the paint is evenly distributed throughout the bristles.

Preparing for side loading: Prior to adding side loads, apply clean water over the painting surface. This will help the paint to go on smoothly and stay wet for a longer period of time. Brush until the surface is smooth and satiny and the water is evenly distributed, then add color for shade or highlight (see page 6 for how to side load). Allow each application of color to dry before re-wetting and applying the next color.

Floating medium: Delta Color Float helps to reduce ridging of the paint and will aid in the floating and side loading of color into the brush. Add one drop to each ounce of water in your brush basin.

Tipped: Load the brush in the first color listed, blend on palette, then place the very tip of the brush into the next designated color. Touch the brush on the palette paper to remove excess. This gives a lovely two-colored effect when stroked.

Spatter: Varnish the project or area to be spattered. Make a thin puddle of paint on the palette paper. Lay the bristles of an old toothbrush into the paint puddle, and while holding the brush in one hand, bristles facing the project, use the thumb of the opposite hand to stroke the bristles over the piece, creating a spray over the project.

Basecoating: Most of the design elements are totally blocked in with a basecoat of color. It may be necessary to apply several applications of color to achieve the desired opacity.

Layering or pyramiding: All paintings are created through a process of building values on top of one another, creating the form by highlighting and shading. Each time additional color is added on the top of a previously applied color, concentrate the new color within a smaller area, thus layering or pyramiding to a peak of color.

Shading: Apply a darker value of color over the basecoat color. When painting with a defined light source, the shade will normally fall on the side of the object opposite the light source. The shade color may also fall in underneath areas where two or more design elements overlap.

Highlighting: The addition of a lighter value of color. It is normally applied on the top element of overlapping elements. When painting with a defined light source, the highlight will normally fall on the side of the object closest to the light source.

Varnishing: Using a 1-inch (25mm) wash brush, varnish all completed paintings using Delta satin, matte or glossy varnish. Follow manufacturer's instructions.

VIOLAS ALL AROUND

Flirting softly around this woven basket, delicate violas show off their colors—every bit as vibrant as the real blossoms planted inside.

Each delicate bouquet is connected with a pretty yellow ribbon, *winding this way and that around the basket.*

It's amazing how just a few strokes and a little bit of paint can so beautifully transform this simple object.

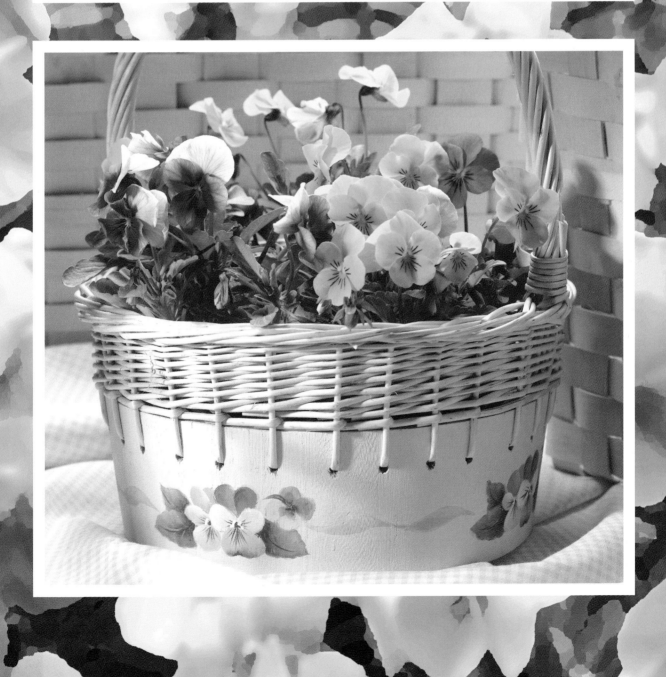

Purple

Lilac

Lavender

Dark Foliage
Green

Crocus
Yellow

Antique
White

Straw

Wedgwood
Green

White

VIOLAS ALL AROUND

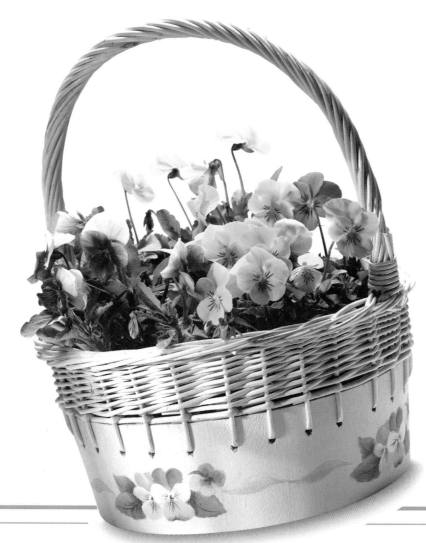

Supplies
Basket
Sandpaper
Delta All-Purpose Sealer
Delta Matte Varnish

Techniques
Comma strokes, side load, S-stroke, double load, brush-mix

Brushes
no. 1 liner
nos. 6 and 8 filberts
no. 8 shader
1-inch (25mm) wash brush

Prep
Sand and seal the wood part
of the basket only. Then sand
again.

Background and Transferring Design:

Basecoat the surface of the basket using Antique White and the 1-inch (25mm) wash brush.

Trace the pattern and transfer onto the basket four times, spacing evenly.

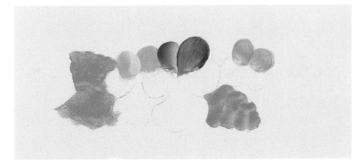

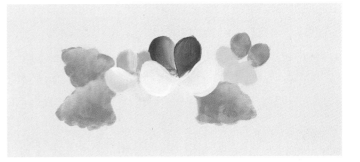

1. Leaves: The leaves should be completed first since the flower strokes are pulled over the leaves. With a no. 8 shader, base the leaves with Wedgwood Green.

Violas: Paint the violas in the back first, then the one in the front. Using a no. 6 filbert and Lilac, pull a comma stroke (see page 6) for each petal. Stroke the overlapping petal on the left again, using a comma stroke and a double load of Lilac and White.

Using a no. 8 filbert, pull comma strokes on the upper middle petals with a brush-mix (see page 8) of Lavender + Purple. Restroke the left petal with a double load of Lavender and Purple adding White on the right side.

2. Leaves: Highlight the upper side of the leaves with a transparent side load of Crocus Yellow and the no. 8 shader. When dry, add a second coat.

Violas: Pull comma strokes for the yellow petals with a double load of Crocus Yellow and White and the no. 6 filbert. The White side of the comma strokes should be facing up.

Use a no. 8 filbert to stroke the middle petals with a brush-mix of White + a smidgen of Lavender.

3. Leaves: Sideload a no. 8 shader with Dark Foliage Green and shade as in the photo.

Violas: With a no. 6 filbert and Crocus Yellow, pull two side-by-side comma strokes for the lower petal.

Double load a no. 6 filbert with Crocus Yellow and White and re-stroke the lower petal on the left side to further overlap the leaf.

Using the no. 8 filbert, stroke the bottom petals with a brush mix of Crocus Yellow + Straw. Paint the lower petal using two side-by-side comma strokes.

Side load a no. 8 shader with Crocus Yellow and shade where the middle petals connect in the center. With a no. 8 shader, side load with Lavender and shade the outer edges of the middle petals.

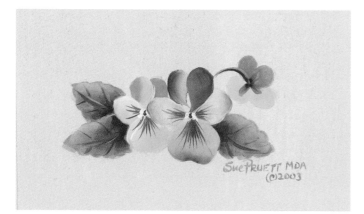

4. Leaves: Brush-mix Wedgwood Green + Dark Foliage Green and apply the vein lines with the no. 1 liner. Using the no. 8 shader, side-loaded in Dark Foliage Green, re-shade the leaves underneath the flower petals. Stroke in the stem with the no. 1 liner and Wedgwood Green. Line the upper edge of the stem with Crocus and the lower edge with Dark Foliage Green.

Violas: With a no. 8 shader, side load Lavender on the bottom edge of the lower petal; repeat using Purple within a smaller area of Lavender. Load a no. 1 liner with Purple + water making an inky consistency and add the fan-shaped fine lines coming from the center of the flower, pulling out. Add a Purple dot in the center of the viola. Dip just the tip of the liner brush into White and stipple a white fuzzy mustache in an upside-down V shape on each side of the dot.

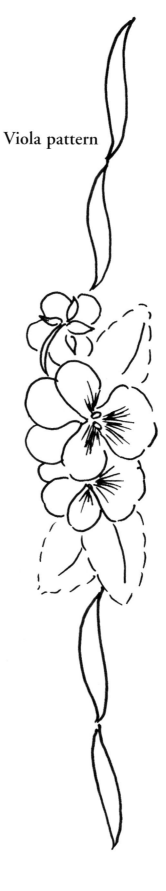

Viola pattern

5. Ribbon: Double load a no. 8 shader with Crocus Yellow and White. Stroke an S-stroke (see page 6) with the White side of the brush facing up.

Varnish with Delta Matte Varnish.

**Daisy pattern
page 13**

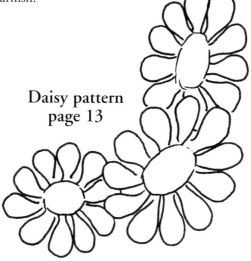

White

Crocus Yellow

Light Ivory

Medium Foliage Green

Payne's Grey

Raw Sienna

Straw

DELIGHTFUL DAISIES

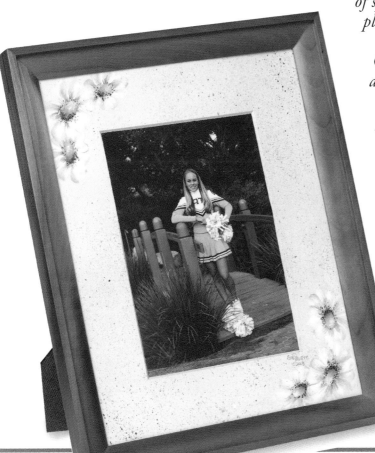

Daisy blossoms and a soft sprinkling of spattered-paint enhance a plain photo mat to sweetly accent a family photo. Created with easy strokes and stippling, these dainty flower trios add to the fresh, innocent quality of the accompanying picture. The buttery yellow, green and white colors bring out similar shades in the photo, a match that would be hard to find in a store. How wonderful to create your own artistic, "custom-framed" look and skip the professional fees!

Supplies

Mat and frame
Transparent tape
Cotton swabs
Delta All-Purpose Sealer
Delta Matte Varnish
Cardboard
Old toothbrush for spattering

Brushes

no. 1 liner
no. 4 round
no. 8 shader
1-inch (25mm) wash

Brush Techniques

Comma stroke, side load, tipped, stipple, and spatter

Prep: To create a work surface, cut a piece of cardboard twice the size of the mat. Tape the cardboard to the back of the mat.

Brush an application of sealer to the mat. Let dry. Transfer the daisy pattern to the mat.

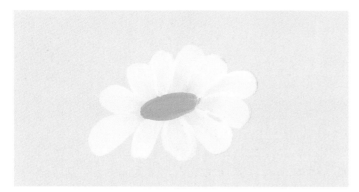

1. Daisies: Paint the petals with comma strokes using a no. 4 round and Light Ivory, pulling from the edge of the petal to the center.

Centers: Basecoat the centers of the daisy with Straw and the no. 4 round.

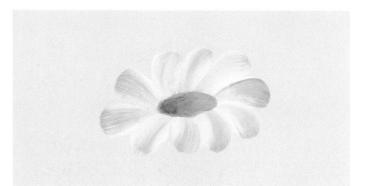

2. Petals: Re-stroke with Light Ivory tipped into Straw.

Centers: Side load the no. 8 shader with Raw Sienna and shade the left side of the center.

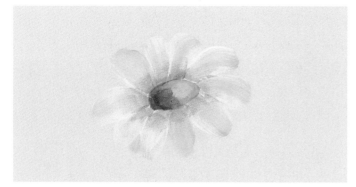

3. Petals: Side load the no. 8 shader with Medium Foliage Green and shade where the petals connect to the center.

Centers: Stipple in the light areas with Crocus Yellow using a no. 1 liner.

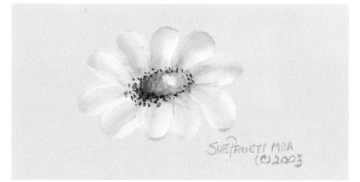

4. Petals: Using a no. 8 shader, side load into White. Highlight on the right side edge of overlapping petals.

Centers: Stipple with White in the center of the Crocus Yellow area with the no. 1 liner.

Dot the pollen around the center of the daisy with Payne's Grey using the no. 1 liner.

Finish: Apply a thin coat of varnish and let dry. Load an old toothbrush with Medium Foliage Green and spatter over the background area. Wipe off any unwanted spatter on daisies using a cotton swab.

Apply Delta Matte Varnish using a 1-inch (25mm) wash brush.

Antique White

Dusty Mauve

Forest Green

Light Ivory

Lisa Pink

Sea Grass

Wedgwood Green

Pale Yellow

Stonewedge Green

TULIP TIME

A single, reclining tulip beautifully accents the shape of this wooden planter, and illustrates the virtues of artistic understatement. The stage is set with a weathered, white backdrop streaked with a "timeworn" green border. This charming planter would certainly be the belle of any sunny, window box scene.

Supplies
Wooden planter (Walnut Hollow)
Sandpaper
Delta All-Purpose Sealer
Delta Exterior/Interior Varnish

Brushes
no. 8 filbert
nos. 8, 12 shaders
½-inch (12mm) wash brush
1-inch (25mm) wash brush

Brush Techniques
Side load, chisel edge

Prep: Sand the wood and seal with Delta All-Purpose Sealer. Let dry, then sand again. Using a 1-inch (25mm) wash brush, basecoat the planter with Antique White.

Planter: Using a 1-inch (25mm) wash brush and a thinned mixture of Forest Green, apply transparent streaks. To do this, load the brush into Forest Green and lay the brush on the outer edge of the box and pull horizontally across the box on all edges including the bottom edge. Let dry and repeat for desired effect. Sand to distress. Position tracing paper onto the surface, slip gray graphite between the pattern and the surface and re-trace using a light touch.

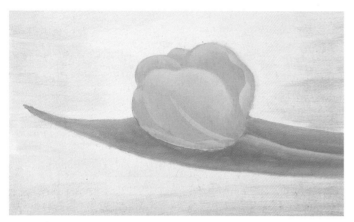

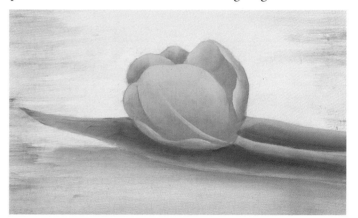

1. Tulip: Basecoat the tulip using Lisa Pink + Antique White (2:1). Using a no. 8 shader, side load into a mix of Lisa Pink + Light Ivory (2:1). Highlight as indicated in the photo. Apply this mixture several times for good coverage. Using the same color and brush, set the brush down on the chisel edge (see page 6) to apply the center vein line.

Leaf: Basecoat the leaf and stem with Wedgwood Green. Using a ½-inch (12mm) wash brush, side load into Sea Grass and apply Sea Grass horizontally along the front and back edge. Side load a no. 12 shader with Sea Grass and lighten the upper edge of the stem.

2. Tulip: Using a no. 8 shader, side load into a mix of Lisa Pink + Dusty Mauve (1:1) and shade tulip petals as indicated in the photo. Apply this several times for good coverage.

Leaf: Side load a ½-inch (12mm) wash brush with Forest Green + Wedgwood Green (1:1) and shade along the leaf and stem as indicated in the photo. Using the same brush side-loaded into Stonewedge Green, apply under the leaf, creating a shadow.

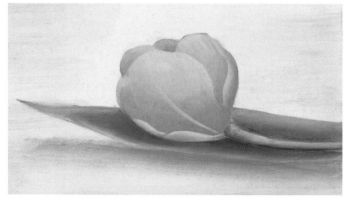

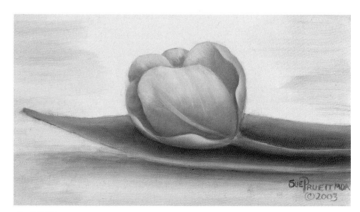

3. Tulip: Using a no. 8 shader, side load into a mix of Light Ivory + Lisa Pink (3:1) and highlight by layering (see page 8) with the same color within the previous light area.

Leaf: Side load a ½-inch (12mm) wash brush with Pale Yellow to lighten within the previous light area. Shade the stem with a side load of Forest Green + Wedgwood Green (1:1) using a no. 12 shader.

4. Tulip: Side load a no. 8 shader into Dusty Mauve and add darker areas as indicated in the photo. Load a no. 8 filbert with Light Ivory + Lisa Pink (3:1), then set the brush on the upper right of the front petal. Staying on the tip of the brush, stroke some diagonal lines gravitating toward the vein line.

Leaves: Using a ½-inch (12mm) wash brush, side load into Forest Green and shade again under the stem to cast a shadow.

Finish: Apply Delta Matte Varnish with a 1-inch (25mm) wash brush.

Tulip pattern

Hydrangea pattern
page 18

Lavender

Periwinkle
Blue

Purple Smoke

Straw

Seashell
White

Golden
Brown

Green Sea

Deep Coral

Blueberry

HEAVENLY HYDRANGEAS

Hydrangea fans will love this little basket, which pays artistic tribute to the colorful abundance of these amazing blooms. This accent piece brings a fresh breath of spring wherever it rests. Blues and pinks layered in cool and warm tones create depth and the illusion of a ball shape, while simple petal strokes form the details of this favorite flower.

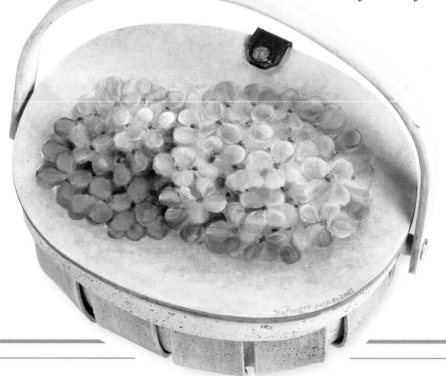

Supplies
Basket (Provo Craft)
Sandpaper
Small sea sponge
Old toothbrush
Delta All-Purpose Sealer
Delta Matte Varnish

Brushes
no. 1 liner
nos. 6, 8 filberts
no. 8 shader
1-inch (25mm) wash brush

Brush Techniques
Comma stroke, tipped, stipple, slip-slap, spatter

Prep: Sand the lid of the basket and seal with Delta All-Purpose Sealer. Let dry, then re-sand. Using a 1-inch (25mm) wash brush, basecoat the lid and basket using Seashell White. Let dry. Use a 1-inch (25mm) wash brush to moisten the lid with clean water. Load the brush with Green Sea and slip-slap (see page 6) onto the lid. Pounce with a moistened sea sponge, then let dry. Thin Green Sea with water and add to some of the basket weaves and edge of lid. Mask top of lid and spatter sides of basket with unthinned Green Sea. Transfer the pattern to the basket lid.

Allow to dry, then sand to soften and expose the wood.

1. With a 1-inch (25mm) wash brush, form each ball shape of the flowers with a loose slip-slap of Periwinkle Blue. On the top right section slip-slap using Deep Coral. On the lower left, slip-slap with Lavender, then Purple Smoke.

2. Load the no. 6 filbert with Deep Coral tipped into Seashell White. Starting in the upper right area, pull comma strokes (see page 6) for the individual flower petals.

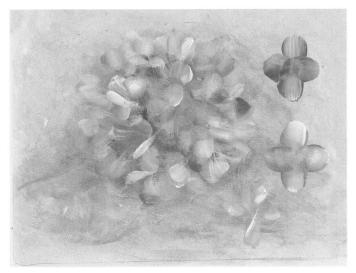

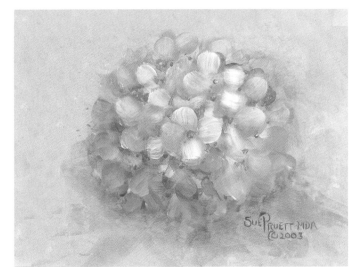

3. Use a no. 6 filbert loaded with Periwinkle Blue tipped with Seashell White to lighten the tops of the petals. Starting on the outside edge, pull petal strokes to continue forming the ball shape. Paint lighter petals in the upper right and outside edges. Continue with Periwinkle Blue petals and Lavender petals on lower left area. Create a variety of sizes and colors.

Form some four-petal flowers like the pink one in the upper right corner.

4. Side load a no. 8 shader with a mix of Periwinkle Blue + Blueberry (1:1) to shade underneath overlapping petals. Using a no. 1 liner brush, dab into a brush-mix (see page 8) of Blueberry + Green Sea for the darker areas and Golden Brown for the lighter areas, then stipple (see page 7) round shapes for flower centers. These can be placed where four petals come together to form a flower. Continue dabbing highlights on the center by brush-mixing into Straw and/or Seashell White.

Finish: Apply Delta Matte Varnish using a 1-inch (25mm) wash brush.

 Tompte Red

 Straw

 Purple

 Pine Green

 Periwinkle Blue

Payne's Grey

 Vintage Wine

 14K Gold Gleams

 White

PRETTY PANSIES

This exquisite plate looks like a family heirloom—your own, once you've placed your signature alongside the gorgeous, hand-painted artwork. Though these vibrant pansies look complicated, they're simply created with a series of layered comma strokes and easy line work.

Supplies
Wooden plate (Walnut Hollow)
Sandpaper
Delta All-Purpose Sealer
Delta Matte Varnish

Brushes
nos. 1, 10/0 liners
no. 10/0 script liner
no. 8 filbert
nos. 8, 10 shaders
1-inch (25mm) wash
brush

Techniques
Comma strokes, side load,
double load, brush-mix,
flip float

Medium
Foliage Green

Lilac

Lavender

Golden
Brown

Black Cherry

Black

Prep: Sand the wooden plate, then seal with Delta All-Purpose Sealer. Let dry and sand again.

Using a 1-inch (25mm) wash brush, basecoat the center section of the plate with a mix of Black Cherry + Payne's Grey (3:1). Basecoat the outer rim of the plate with Black.

Transferring Designs: Trace the pattern onto tracing paper and lightly transfer to the surface.

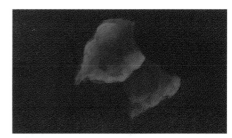

1. Leaves: All leaves are shaded and lightened with the same colors but the front leaves should be a touch lighter than the back leaves.

Using a no. 8 shader, basecoat the front leaves with a brush-mix (see page 8) of Pine Green + Medium Foliage Green. Base the back leaves with Pine Green.

2. Side load a no. 8 shader with Medium Foliage Green and add highlights on leaves as shown.

3. Using the no. 8 shader side loaded with Pine Green + Payne's Gray (2:1), add shadows as shown using a flip float (see page 7).

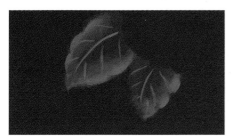

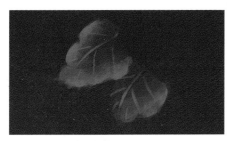

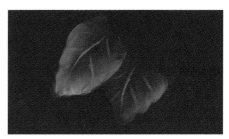

4. Load a no. 1 liner with Medium Foliage Green mixed with water to an inky consistency and apply vein lines.

5. Use a no. 8 shader side loaded with Black Cherry to shade the darkest area of the leaves.

6. Side load the no. 8 shader with Golden Brown and add highlights to the front leaves. Side load the no. 8 shader with Periwinkle Blue and add a highlight on the tip of some leaves. Using a no. 10/0 script liner, load into Medium Foliage Green and add highlights to the center of the vein lines.

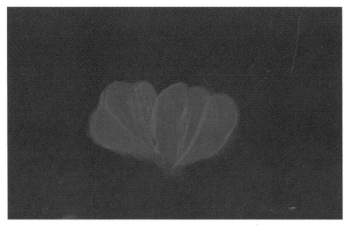

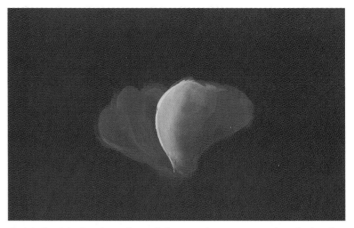

1. Pansies: Referring to the pattern on the facing page, completely paint the #2 and #3 pansies prior to #1 pansy.

Paint the back petals of the three pansies using the same technique and the following paint mixtures: **#1 pansy**, brush-mix Vintage Wine + Lavender; **#2 pansy**, brush-mix Tompte Red + Black Cherry; **#3 pansy**, brush-mix Vintage Wine + Periwinkle Blue.

Pull comma strokes (see page 6) on the upper back petals prior to starting the middle petals. Repeat this until almost opaque. Apply the last comma stroke to the front petal that overlaps the back petal.

2. To highlight the edge of the overlapping petal, side load a no. 10 shader with Lavender for the **#1 pansy**, Tompte Red + Lavender for the **#2 pansy** and Periwinkle Blue for **#3**.

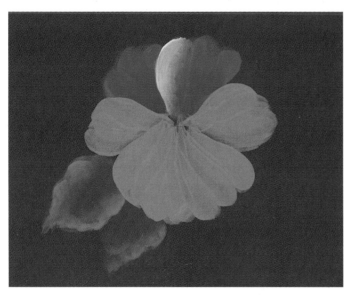

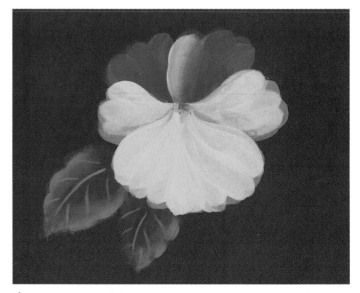

3. Using a no. 8 filbert, pull comma strokes for the front petals as follows: **#1 pansy** with Golden Brown; **#2 pansy** with Tompte Red; and **#3 pansy** with Periwinkle Blue.

4. Using a no. 8 filbert, stroke over the previous petals as follows: **#1 pansy** with Straw; **#2 pansy** with a brush-mix of Tompte Red + Black Cherry; **#3 pansy** with Lilac. Let some of the under color show through to add interest.

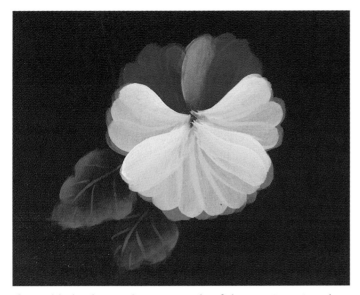 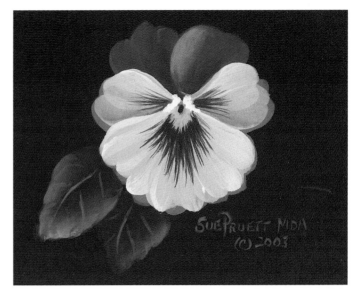

5. Highlight the overlapping petals of the pansies using the no. 8 filbert as follows: **#2 pansy,** double load Tompte Red and Lavender + White; **#3 pansy,** use Periwinkle Blue + White; **#1 pansy,** use a double load of Straw and White. Shade the petals using the no. 10 shader as follows: **#2 pansy,** double load of Purple and Payne's Grey; **#3 pansy,** double load of Vintage Wine and Purple; **#1 pansy,** side load into Golden Brown to shade the middle petals behind the front petal.

6. Load a no. 8 filbert with Straw for the **#1 pansy.** Blend on palette, then tip into White and re-stroke the front petals. For the **#2 pansy,** use Tompte Red and Lavender; for the **#3 pansy** use Periwinkle Blue and White. Using a no. 10/0 liner add water to an inky consistency, then pull face lines from the center of the pansy outward. Use the following colors: **#1 pansy,** line with Vintage Wine then add shorter lines of Purple. For **#2 pansy** use Black Cherry with shorter lines of Purple. For the **#3 pansy** use Vintage Wine with shorter lines of Purple. Paint the beards with Straw and the center dot with Purple. Dab on the mustache with the liner brush dipped in White for a fuzzy look.

Pansy pattern

Finishing

Follow the photograph on page 20 to paint the border design of comma strokes and dots using a no. 8 filbert and 14K Gold Gleams.

Apply several coats of Delta Satin or Matte Varnish, drying between coats.

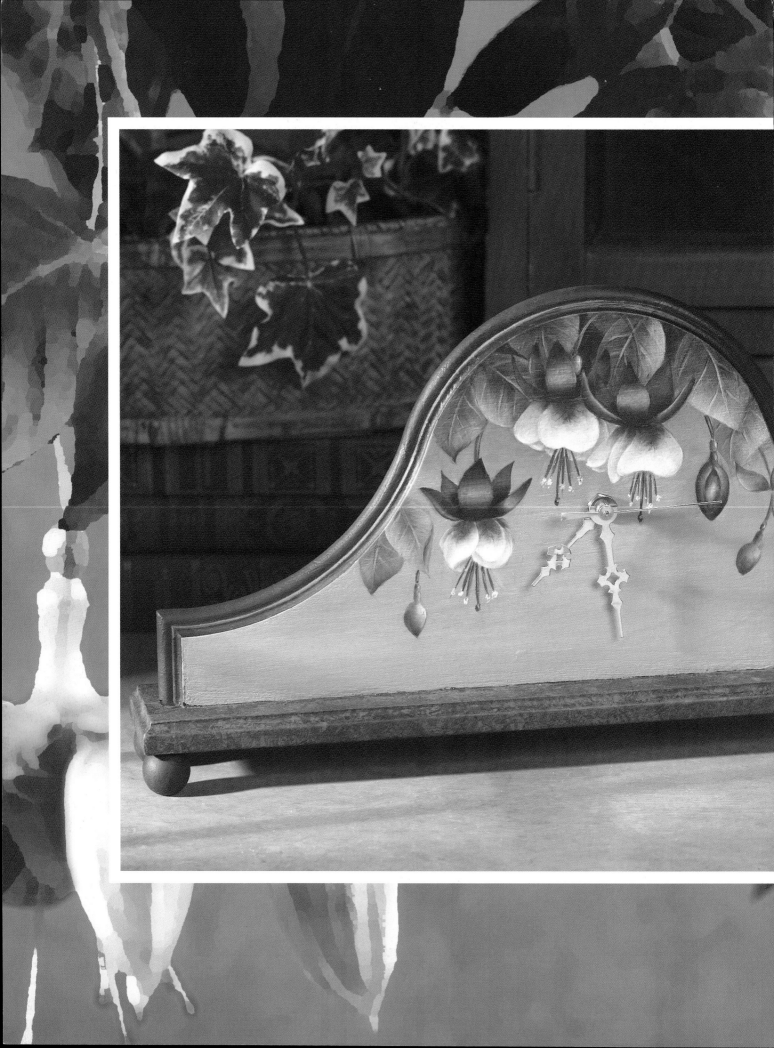

TIMELESS FUCHSIAS

Luscious fuchsias artfully cascade from the top rim of this radiant clock. Painted to perfection in shades of red, green and pink, this clock is as much an artpiece as a timepiece.

The background of the clock includes an interesting faux finish technique in shades of garden green, the edges a dark forest green. Realistic leaves and buds complete this lifelike design. All that's left is the addition of the clockworks and it's time to admire your finished project.

Persimmon

Light Foliage Green

Medium Foliage Green

Light Ivory

Lichen Grey

Fruit Punch

Raw Linen

Tomato Spice

Wedgwood Green

TIMELESS FUCHSIAS

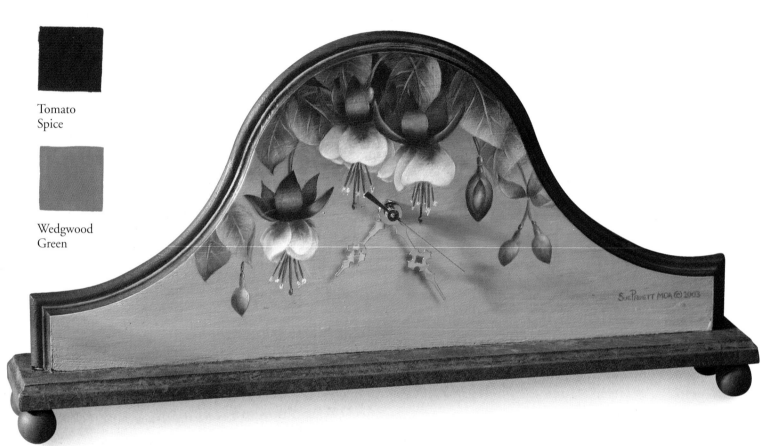

Supplies:

Clock (Walnut Hollow)
Sandpaper
Delta All-Purpose Sealer
Delta Matte Varnish

Brush Techniques

Flip float, side load, brush-mix, liner work

Brushes

no. 10/0 script liner
no. 8 shader
1-inch (25mm) wash brush

Prep: Sand the clock lightly. Basecoat the surface using a 1-inch (25mm) wash brush and Blue Wisp. While the paint is still wet, apply some streaks of Wedgwood Green into the Blue Wisp. Transfer the design.

| Dark Foliage Green | Blue Wisp | Black Green | Pale Yellow | Antique White | Alpine Green |

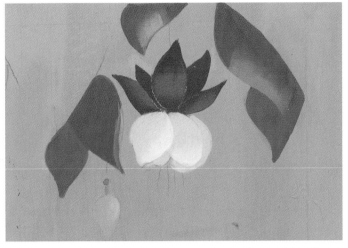

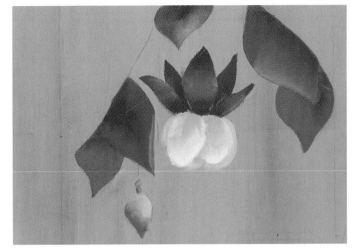

1. Basecoat the top petals using a no. 8 shader and Fruit Punch, the lower petals with Raw Linen. Basecoat the front leaves with Medium Foliage Green, the back leaves with Alpine Green + Blue Wisp (1:1). Basecoat the buds and caps with Light Foliage Green. Side load a no. 8 shader with Persimmon + Raw Linen (1:1) and apply to top petals using a flip-float technique (see page 7) in the center area of the front petals and a side load on edges of other petals as shown. Apply two to three times for good coverage.

Using a no. 8 shader, side load into Antique White and highlight the lower petals. Side load a no. 8 shader with Light Foliage Green and highlight the front leaves. Use a no. 8 shader side loaded with Raw Linen to highlight the upper right side of the buds.

2. With a no. 8 shader, side load into a mix of Raw Linen and Lichen Grey (1:1). Apply to the lower fuchsia petals as pictured. Using the no. 8 shader, side load into Tomato Spice to darken the upper fuchsia petals. Using the no. 8 shader, side load into Persimmon to shade the lower left side of the buds.

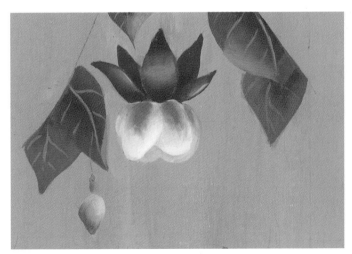

3. Using a no. 10/0 script liner, brush-mix (see page 8) water and Light Foliage Green to an inky consistency. Apply vein lines to leaves. Side load a no. 8 shader with Light Foliage Green and add highlights to the front leaves, pyramiding (see page 8) within the previous light areas. Using a no. 8 shader, side load into Persimmon and add to the lower petals using a flip-float technique. Shade the lower left side of the buds with a side load of Tomato Spice and a no. 8 shader, pyramiding within the dark area. Enhance the highlighting of the top petals with Persimmon + Raw Linen.

Hint:
When side loading, moisten the area to be painted with clean water first.

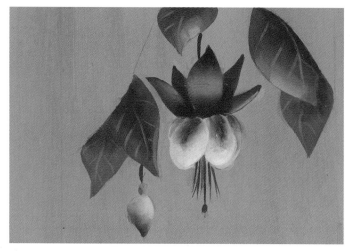

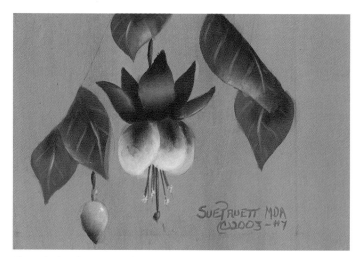

4. Using the no. 10/0 script, brush-mix an inky consistency of Fruit Punch + water and paint stamens, pulling down from between the front and back lower petals. Repeat the same for the flower stems.

With a no. 8 shader, side load into a mix of Dark Foliage Green + Black Green (1:1) to add darker areas to the front leaves.

Side load a no. 8 shader with Dark Foliage Green + Alpine Green (1:1) to add darker areas to the back leaves. Use a no. 8 shader side loaded with Tomato Spice to further darken the lower petals using a flip float technique.

5. Side load a no. 8 shader with Tomato Spice to accent the front leaves. Side load with Persimmon to accent the back leaves. Reinforce the veins with a no. 10/0 script liner and Light Foliage Green.

Load a no. 10/0 script liner into Pale Yellow to dot tips of stamens, then dot the upper right of the pollen with Light Ivory. Load the script liner with a brush-mix of Persimmon + Pale Yellow and stroke a line down the right side of the stems and stamens. Repeat on the left side using Tomato Spice.

Tip the no. 10/0 script liner with Light Ivory and dot highlights on the upper right of the buds.

Load the script liner with Pale Yellow to highlight the center half of the vein lines on the front leaves.

Clean up any messy outside edges with Blue Wisp.

Finish with a coat of Delta Matte Varnish.

Fuchsia pattern

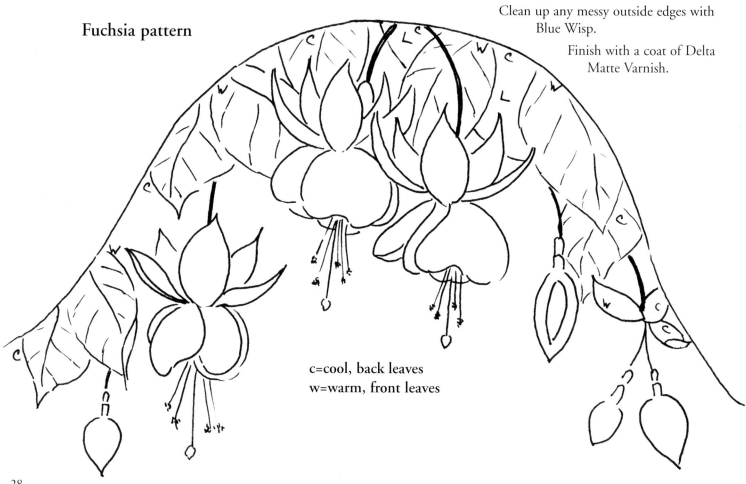

c=cool, back leaves
w=warm, front leaves

Alpine Green

Lichen Grey

Grape

Hippo Grey

Light Ivory

Medium Foliage Green

Pale Yellow

Periwinkle Blue

Purple Dusk

Soft Grey

Wedgwood Green

Lavender

GLORIOUS MORNING GLORIES

This trinket box on the nightstand is sure to make each morning a little more glorious! Admiring the look of rich marble on the lid and base, it's difficult to believe this fine piece has humble, wood-hewn origins. Damp paint and smoke from a lit candle create the unique special effects, then coordinating shades of gray are blended and splattered onto the rest of the box. From these smoky depths spring luminous morning glories, placed "just so" for artistic effect.

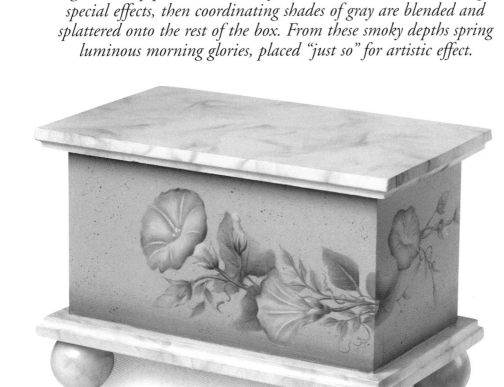

Supplies

Wooden box with ball feet (Walnut Hollow)
Sandpaper
Old toothbrush
Candle and matches
Old knife
Delta All-Purpose Sealer
Delta Matte Varnish

Brushes

no. 1 liner
no. 10/0 script liner
no. 6 filbert
nos. 6, 8, 10, 12 shaders
1-inch (25mm) wash brush

Brush Technique

Side load, flip float, spattering

Prep Sand the wooden box, then seal it using Delta All-Purpose Sealer. Let dry, then sand again.

Use a 1-inch (25mm) wash brush to basecoat the lid, base and feet of the box with Light Ivory. Basecoat the four sides of the box using a 1-inch (25mm) wash brush and a mix of Soft Grey + a smidgen of Lichen Grey. Keep some of this mix in a container for touch ups after the painting is finished.

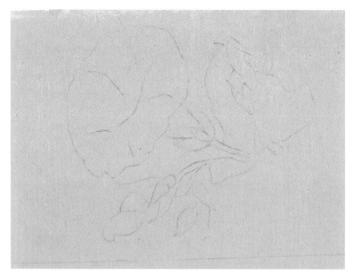

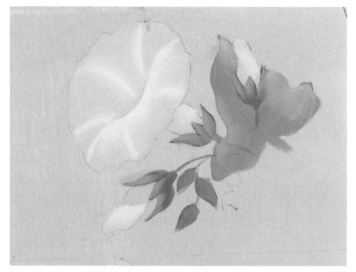

1. Transfer the pattern onto tracing paper. Position tracing onto surface, slip graphite paper between tracing paper and surface, then re-trace using a light touch. Erase any dark graphite lines.

2. Morning glories: Use a no. 8 shader to basecoat the flowers with a mix of Periwinkle Blue + Soft Grey (1:1).

Leaves: Basecoat the leaves using a no. 8 shader and Wedgwood Green + Medium Foliage Green (2:1). Use a no. 6 shader and the same paint mixture for the buds and smaller leaves.

Morning glories: Using a no. 12 shader side loaded with Periwinkle Blue + Light Ivory (2:1), add light areas as shown. Load a no. 1 liner with the same color, stay up on the tip and apply vein lines starting at the center of the flower and pulling to the outer edge. Notice how each vein gravitates to the center of the flower. Side load a no. 8 shader with the same color and apply a flip float (see page 7) on each side of the vein lines.

Leaves: Using a no. 8, 10 or 12 shader (depending on the size of the leaf), side load into a mix of Medium Foliage Green + Pale Yellow (1:1) and lighten leaves as shown in photo.

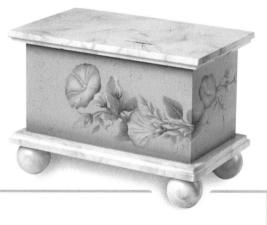

To create the marbled effect:

Apply a basecoat of Light Ivory. While it's still wet, have an assistant hold a knife over a candle flame to make it smoke. Move the wood piece back and forth and in circles through the candle smoke.

Use this technique on the top of the box, the base, and the feet.

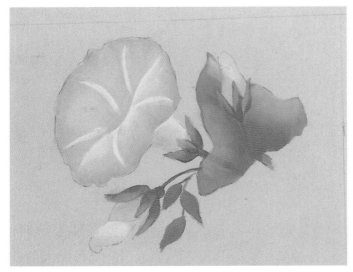

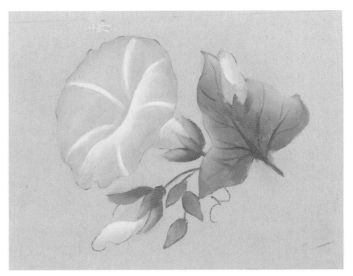

3. Morning glories: Side load a no. 8 shader with a mix of Periwinkle Blue + Soft Grey (2:1) to add dark areas.

Leaves: Using a no. 8, 10, or 12 shader (depending on the size of the leaf), side load into a mix of Wedgwood Green + Alpine Green (1:1) and shade the leaves.

4. Morning glories: Using a no. 8 shader, add highlight areas with a side load of Light Ivory + a smidgen of Periwinkle Blue over the top of the previous lights. Use a no. 1 liner and the same mix of blue to highlight the center area of vein lines. This will add more of a rolled effect.

Leaves: Highlight using a no. 6, 8, or 10 shader (depending on the size of the leaf) with a side load of Pale Yellow + Wedgwood Green (1:1).

Apply vein lines using a no. 10/0 script liner and a brush-mix of Medium Foliage + Alpine Green with water added for an inky consistency.

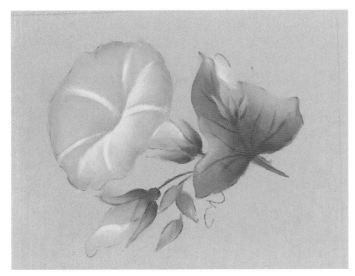

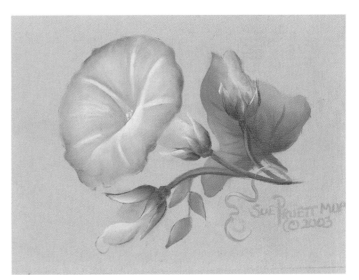

5. Morning glories: Shade using a no. 8 shader side loaded into a mix of Periwinkle + a smidgen of Purple Dusk, pyramiding (see page 8) darkest areas and lightly along vein lines.

Leaves: Shade using a no. 6, 8, or 10 shader (depending on the size of the leaf) side loaded into Alpine Green, pyramiding into smaller areas of darks.

6. Morning glories: Using a no. 8 shader side loaded with Lavender, add accents as pictured. With a no. 8 shader side loaded with Grape, shade as pictured. Load a no. 6 filbert with a brush-mix of Periwinkle Blue + Light Ivory. Stay on the tip of the brush and stroke highlights on the blue area between the vein lines. Make sure to curve in the same direction as the veins.

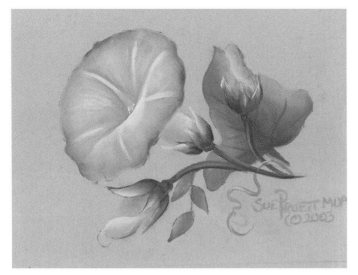

7. Leaves: Side load a no. 8 shader into Lavender and add shading and details as pictured. Use a no. 8 shader to side load with Grape and add further accents as pictured.

The stems are done in two different greens using a no. 10/0 script liner with an inky consistency of paint. Paint the overlapping stems (on top of the other elements) with Medium Foliage Green and the stems in the background area with Wedgwood Green. Paint the tendrils with the same script brush using Lavender. Add a brush-mix of Periwinkle Blue and Light Ivory on some of the rounded areas of the tendrils to add interest.

Finishing: Use a 1-inch (25mm) wash brush side loaded with transparent Hippo Grey to shade along the base of the box. Before spattering, clean up any graphite lines with a kneaded eraser. Spatter (see page 8) area around morning glories using a mix of Wedgwood Green + Medium Foliage Green. Varnish with one application of Delta Matte Varnish.

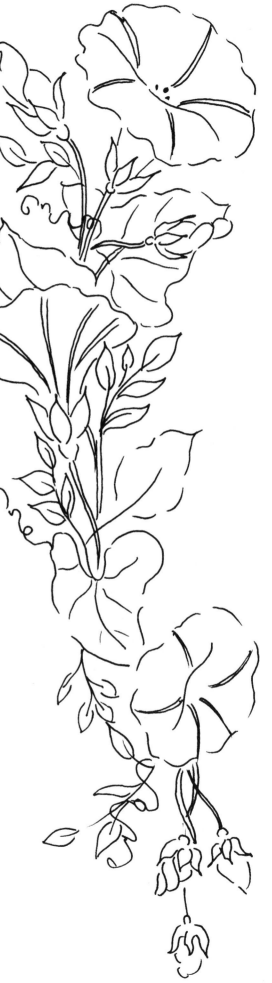

Morning Glory pattern

Golden Brown

Light Ivory

Maple Sugar Tan

Ocean Mist Blue

Raw Sienna

Sea Grass

Forest Green

Chamomile

Black Green

TUSCANY ROSES

The addition of perfect, pale roses accentuates the classic look of these faux-finished planters. This striking pair summons an old world, Tuscan mood, and has decorative potential indoors and out. The finely detailed, realistic roses look like the work of an accomplished artist, but each flower starts with a basic circle and is completed with simple strokes. Shading detail on the petals and leaves create depth, interest, and whisper-soft gradations of color.

Stonewedge

Straw

Taupe

Tropic Bay Blue

Wedgwood Green

Supplies
Pair of ceramic vases
Sea sponge
Chalk pencil
Delta Blending Medium
Delta Satin Varnish

Brushes
no. 1 liner
nos. 8, 10 shader
½-inch (12mm) angular
1-inch (25mm) wash brush

Brush Techniques
Slip-slap, double load, chisel edge

Prep: Seal using Delta All-Purpose Sealer. Basecoat the planters with an opaque coverage of a mix of Ocean Mist Blue + Tropic Bay Blue (1:1). Let dry. Using a 1-inch (25mm) wash brush, moisten the background with water and then apply a thin application of Taupe, using a slip-slap technique (see page 6) over the entire surface. Moisten a sea sponge, squeezing out all excess water, and dab up and down on the Taupe to lift off some paint and soften. Let dry. Repeat this process with Stonewedge on top of the Taupe. Sponge off again. Either color can be repeated until the desired color is achieved.

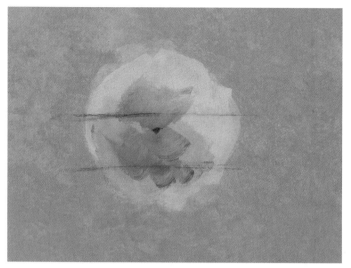

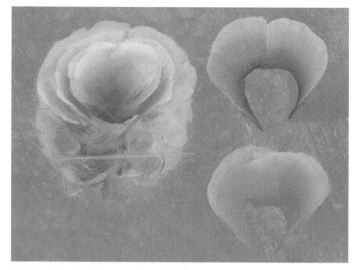

Roses:

1. Transfer the pattern shapes without details.

Using a no. 10 shader, dip the brush into blending medium, working it into the bristles on the palette paper. Load the brush into Chamomile, and slip-slap a ball shape with loose outside edges. Without cleaning your brush, side load into Forest Green and slip-slap the dark area on the lower left (see photo). While still wet, side load into Forest Green to shade the middle. Let dry.

Use a chalk pencil to divide the rose shape into three horizontal sections. Add a dot in the center of the middle section. This dot is very important to the formation of the rose. When pulling strokes, the short end of the angular brush should always be pivoted toward that dot. Practice the rose instructions that follow prior to painting your project.

When painting the roses, clean the brush each time a new step is started and re-apply blending gel to the brush and the dry surface. Then add paint and blend on the palette.

2. Double load a ½-inch (12mm) angular brush with a mix of Maple Sugar Tan + Golden Brown (1:1) on the short end of the brush and Chamomile on the point. Starting at the top center of the rose, stroke three back petals covering the upper third of the rose (A). Stroke side petals, pulling up on the chisel of the brush and dragging to form a V toward the center dot (B). To create a ruffled look on the petals, lay the brush flat on the surface and pull along, lifting here and there (C).

Without cleaning the ½-inch angular brush, tip the point into Light Ivory and the short end into Maple Sugar Tan + Golden Brown (1:1). Blend this mix on the palette and paint another row of back petals just below the previous ones. Stagger the petals so they don't all start and stop at the same spot.

Hint: When painting these roses, I'd suggest using Delta's Gel Blending Medium. It allows the paint to stay wet, so colors can be blended more naturally.

Each time a new step is started, clean the brush and re-apply blending gel to the brush and the dry surface. Then add paint and blend on the palette.

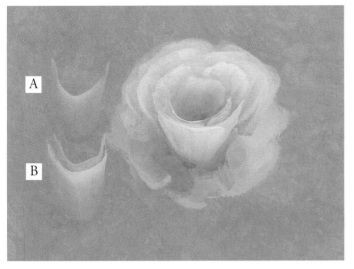

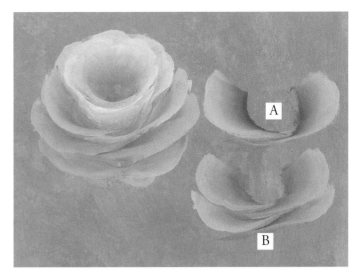

3. To form the front petals, use a ½-inch (12mm) angular brush double loaded with Raw Sienna and Forest Green on the short end and Chamomile or Light Ivory + Chamomile on the pointed edge. Use a C-stroke (see page 7) as illustrated above (A). Hold the angled brush on the chisel edge, pull down on the chisel and flatten the brush forming a U (B). Keep the short end angled toward the center dot. Then pull up on the chisel, connecting the petals.

4. To form the "skirt" of the rose, double load into Raw Sienna + a dot of Forest Green on the short edge and Chamomile on the pointed edge. Starting from the outer edge, with the point of the brush facing out, flatten the brush, then come up on the chisel. Drag the chisel across the front bowl, then slowly lift the chisel (A) so the petal appears to connect to the other side (B).

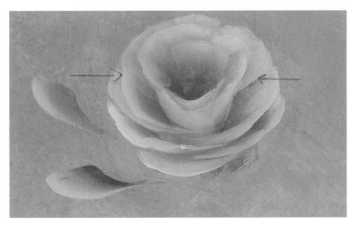

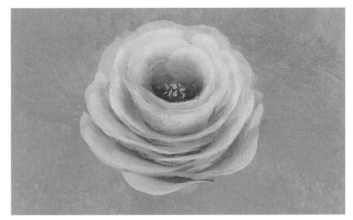

5. To form the bottom petal and the inside petals next to the bowl, continue with the same brush and colors. Close the bottom of the rose with one stroke. Lay the brush under the bottom of the rose, then stroke outward and back up on the chisel edge. Tuck the point of the brush underneath. Double load the ½-inch (12mm) angular brush into Raw Sienna + Straw (1:1) on the short end of the brush and Light Ivory on the tip. Stay on the chisel and connect to the upper inside petal. Stroke the same as the skirt petals (see step 4), pulling the chisel edge across the bowl and gradually disappearing.

6. Blending gel is not needed in this step. Use a no. 8 shader for all of this step. Side load into Forest Green. Add smaller dark areas between the lower left petals, to separate, and inside the bowl. Side load into Light Ivory to highlight the edges of the petals on the upper right. Side load into Ocean Blue Mist to add cool tints on the edges of the lower left petals. Using a no. 1 liner, dab the brush into Raw Sienna and stipple (see page 7) pollen inside the bowl. While still wet, stipple Straw within the previous application of Raw Sienna.

Leaves:

7. Using a no. 8 shader, basecoat the leaves with Wedgwood Green. With the same brush, side load into a mix of Sea Grass + Wedgwood Green (1:1). Lighten the outside edges as shown.

8. Side load a no. 8 shader with Forest Green and shade as shown. Apply the dark area down the center of the leaf using a flip float (see page 7). Using a no. 1 liner, load the brush with an inky consistency of Forest Green and apply vein lines.

9. Using a no. 8 shader, side load into a mix of Forest Green + Black Green (1:1) and apply the darkest areas as shown. Side load the same brush into Sea Grass and pyramid (see page 8) the smaller areas of light on the leaves.

Finishing

Finish with a coat of Delta Satin Varnish.

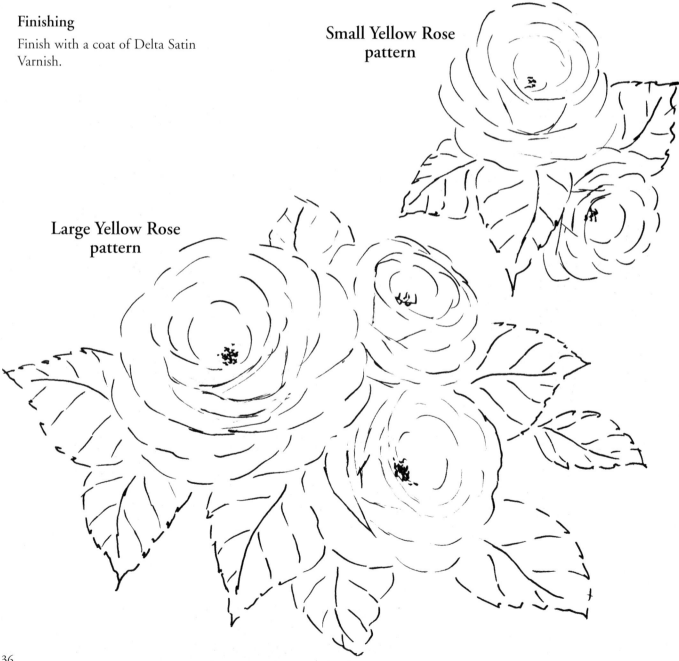

Small Yellow Rose pattern

Large Yellow Rose pattern

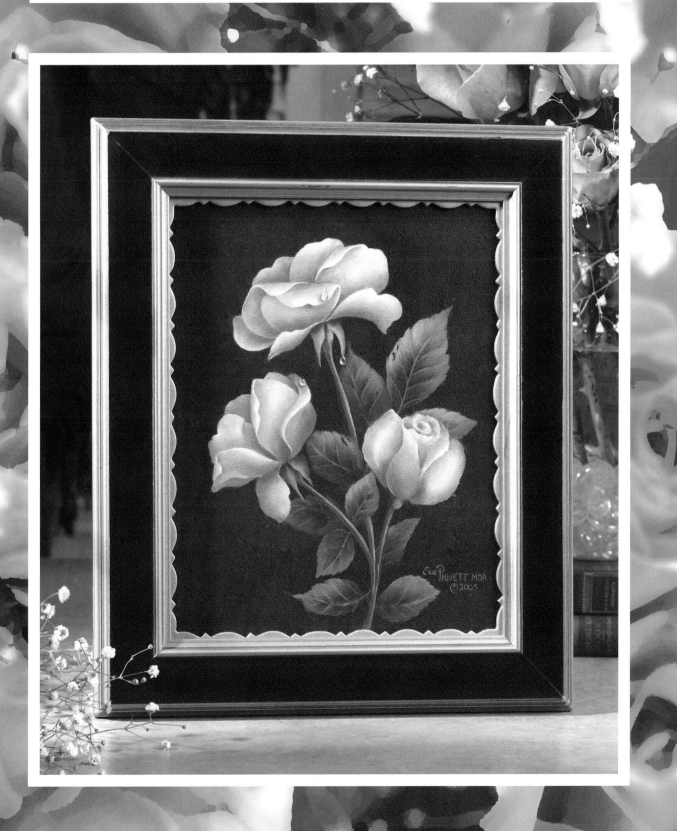

Medium Foliage Green

Light Foliage Green

Dusty Mauve

Dark Victorian Teal

Dark Foliage Green

Black Green

Rose Petal Pink

Sachet Pink

Wedgwood Green

Wild Rose

QUEEN OF THE FLOWERS

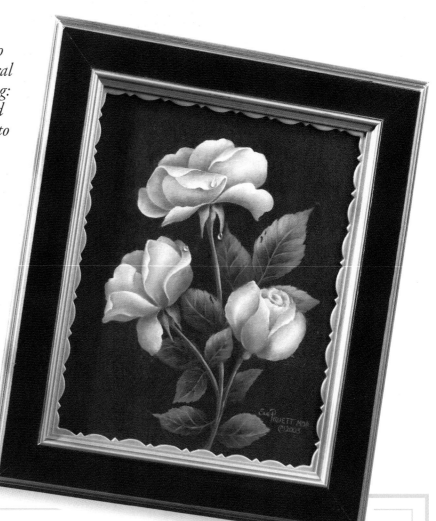

This framed tribute to nature's most prized floral creation proves one thing: decorative painting and fine art can be difficult to distinguish. This beautiful still-life provides ample opportunity to perfect skills such as highlighting and blending for artistic depth perception. Depicting the life cycle of a rose in a dramatic color scheme, this realistic image even includes glistening drops of dew.

Supplies
Canvas, 8" x 10" (20cm x 25cm)
Delta Matte or Satin Varnish

Brushes
no. 1 liner
no. 5/0 script liner
no. 6 filbert
nos. 6, 10 shaders
1-inch (25mm) wash brush

Brush Techniques
Side load, flip float, chisel, brush-mix, line work

Prep: Use a 1-inch (25mm) flat brush to basecoat the surface of the canvas with Black Green. Trace pattern onto tracing paper or clear acetate.

Position pattern on canvas, slip white graphite paper between pattern and canvas. Transfer the design eliminating petal separation lines and details.

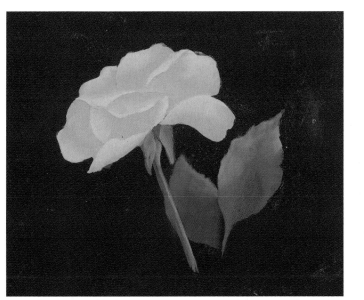

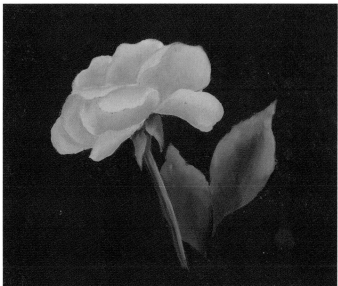

1. Rose: Basecoat with Sachet Pink using a no. 10 shader. Side load a no. 10 shader with a mix of Sachet Pink + Rose Petal Pink (1:1) to separate petals.

Front Leaves: Basecoat using Medium Foliage Green and a no. 10 shader. Highlight as indicated above with a side load of Light Foliage Green and the same brush. Chisel (see page 6) with the same color and the same brush on the right side of the stem.

Back Leaves: With the no. 10 shader, basecoat using Medium Foliage Green + Dark Victorian Teal (1:1). Side load to highlight as indicated above using Wedgwood Green + a dot of Dark Victorian Teal with the no. 10 shader. Chisel the right side of the stem with the same brush and the same color.

2. Rose: To shade under the petals, side load with Sachet Pink + Wild Rose (1:1) + a dot of Black Green with a no. 10 shader. Repeat several times with a transparent (see page 8) mixture of paint and water.

Front leaves: Shade using a side load of Medium Foliage Green + Black Green (1:1) and a no. 10 shader. Apply the center dark area of the leaf using a flip-float technique (see page 7) and the same color and brush.

Back leaves: Shade using a side load of Medium Foliage Green + Dark Victorian Teal (1:1) and a no. 10 shader. Flip float in the center of the leaf with the same color and brush. Also chisel using a no. 10 shader with the same color on the left side of the stem.

Hint: For a transparent application, first moisten the area to be painted with clean water. Side load the no. 10 shader into paint and apply over the top of your previously painted area. Repeat steps several times for complete coverage.

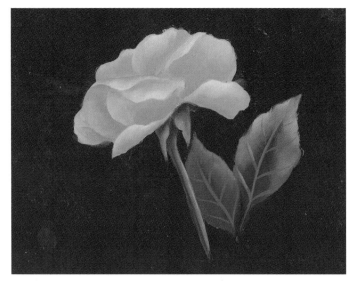

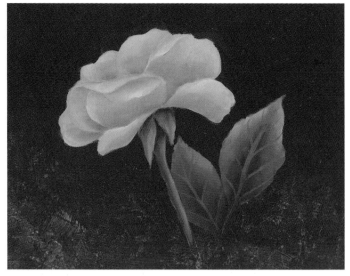

3. Rose: Highlight using a side load of Sachet Pink + Rose Petal Pink (1:1) + a dot of Wild Rose using a no. 10 shader.

Front Leaves: Highlight with a side load of Light Foliage Green + Rose Petal Pink (1:1) and a no. 10 shader.

Using a no. 5/0 liner brush, apply vein lines with Medium Foliage Green thinned to an inky consistency.

Back Leaves: Highlight using a side load of Foliage Green with a no. 10 shader. Using a no. 5/0 liner brush, apply the vein lines with Medium Foliage Green + Dark Victorian Teal (1:1) thinned to an inky consistency. This may not show in some areas; if so, brush-mix into Wedgwood Green.

4. Rose: Further shade with a side load of Dusty Mauve and a no. 10 brush, pyramiding (see page 8) within the previous application.

Front Leaves: Pyramid lightest and darkest areas within previous applications. Highlight with a side load of Light Foliage Green + Rose Petal Pink (1:1) and the no. 10 brush. Darken over the vein lines at the base of the leaf with a no. 10 shader and Medium Foliage Green + Black Green + Dark Foliage Green (1:1:1). Add this mixture to Black Green (1:1).

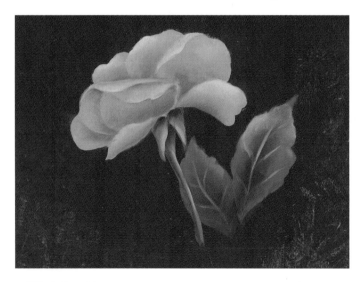

6. Rose: Reinforce the light areas with a side load of Sachet Pink + Rose Petal Pink (1:1) + a dot of Wild Rose and a no. 10 shader. Pyramid this over the top of the previously applied light areas.

Front Leaves: Add side-load tints (again with the no. 10 shader) of Dusty Mauve at the edges of the light areas of the leaves (see photo) and then add some Dark Victorian Teal here and there on the opposite edges of the leaves. Add a few highlights to the vein lines with the no. 5/0 liner and Light Foliage Green.

Back Leaves: Add side-load tints here and there of Dusty Mauve and Victorian Teal as you did with the front leaves. Add highlights to veins, also as you did with the front leaves.

 Green Dew Drops: Using a no. 6 shader, side load with Light Foliage Green on the left side of the dew drop as shown in photo.

Shade below and on the upper right inside with a transparent side load of Black Green.

Add dots of White using the tip of the liner brush.

 Rose Dew Drops: Side load a no. 6 shader into Sachet Pink + Rose Petal Pink (1:1) and stroke the left side of the drop.

Side load the dark areas with Sachet Pink + Rose Petal Pink (1:1) also with the no. 6 shader.

Make different sparkle dots using White and a no. 1 liner.

Finish with a coat of Delta Matte or Satin Varnish.

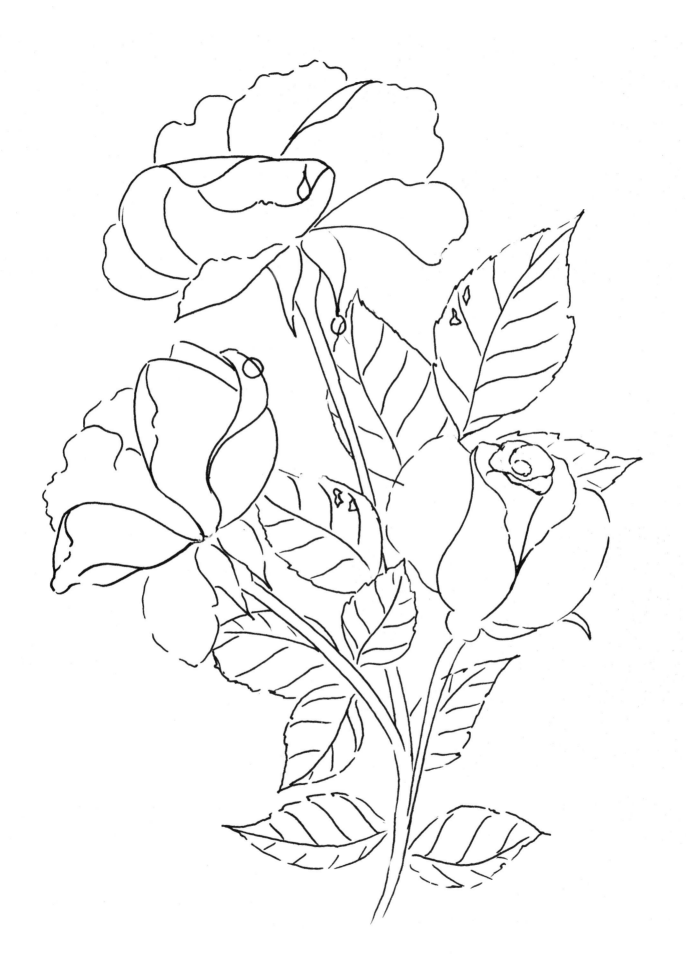

Pale Lilac

Pale Yellow

Medium Foliage Green

Lilac Dusk

Lilac

Light Ivory

Rainforest Green

Straw

Vintage Wine

Raw Linen

White

14K Gold Gleams

IRIS MEMORY ALBUM

Graceful lines and brilliant color create a majestic, bearded iris to decorate the cover of a photo album. This project includes fun techniques for creating subtle, background stripes along with the lavishly detailed floral scene. A metallic-gold border around the oval opening adds to the drama and brings out golden yellow paint tones, the perfect complement to the exotic purple bloom.

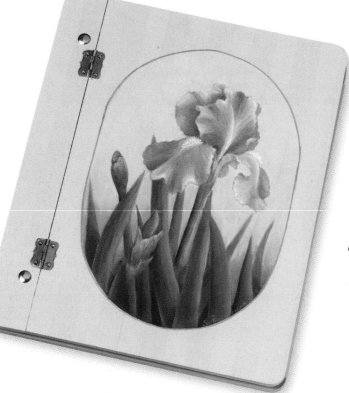

Supplies

Wooden photo album (Walnut Hollow)
Transparent tape
T-square ruler
Chalk pencil or pencil
Delta All-Purpose Sealer
Delta Waterbased Varnish Matte

Brushes

no. 1 liner
no. 10/0 script liner
no. 6 filbert
nos. 8, 10 shaders
½-inch (12mm) wash brush
1-inch (25mm) wash brush

Brush Techniques

Side load, flip float

Light Foliage
Green

Leprechaun

Lavender

Golden
Brown

Dark Foliage
Green

Chambray
Blue

Prep: Sand the wood, then seal using the 1-inch (25mm) wash brush and Delta All-Purpose Sealer

Background: Base with the 1-inch (25mm) wash brush and Chambray Blue.

Stripes. Mark off lines every ¾" (1.9cm) onto the surface of the album cover using a chalk pencil or pencil and the T-square ruler. Then apply tape on every other section. Secure edges of the tape to keep the paint from bleeding. Paint exposed stripes with Chambray Blue + Raw Linen (1:1). Use a ½-inch (12mm) wash brush and press down on the bristles to fill the ¾" (1.9 cm) space. Let dry, then pull off the tape and erase any unwanted markings.

Transfer the oval from the pattern to the surface. Basecoat the oval area with Chambray Blue over the stripes. Paint the oval line with a no. 1 liner and Gold Gleams.

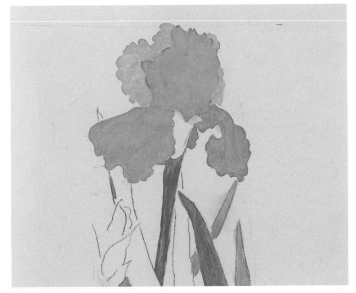

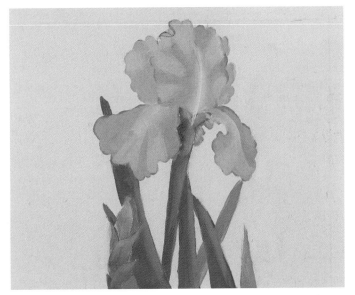

1. Iris: Basecoat the foreground iris petals in Lilac using a no. 8 shader. Use the same brush with Lilac + a dot of Chambray Blue for the petal in back.

Front leaves and stems: Basecoat with Leprechaun + Medium Foliage Green (1:1) using a no. 8 shader.

Back leaves: Basecoat with Leprechaun + a dot of Chambray Blue.

Buds: Basecoat in Lavender using the no. 8 shader.

Bud leaves: Basecoat in Golden Brown also with the no. 8 shader.

2. Iris: Paint the light areas using a no. 6 filbert and Pale Lilac + Lilac (1:1). Note the shapes of the light areas on the photo. Using a no. 8 shader, paint the vein down the front of the iris using a flip float (see page 7) of Pale Lilac + Light Ivory (1:1). To do this, turn the painting upside down and start at the base of the petal, pulling upward toward the top of the petal.

Leaves: Using a no. 8 shader, highlight with a side load of Light Foliage Green for front leaves and a mix of Leprechaun + Pale Yellow (1:1) for the back leaves. Paint the bud leaves with the no. 8 shader and Straw.

Let dry, then repeat for better coverage.

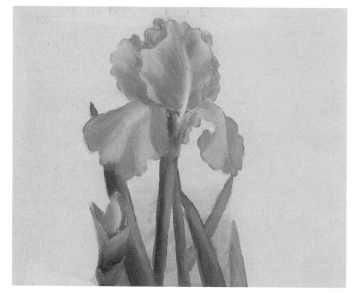

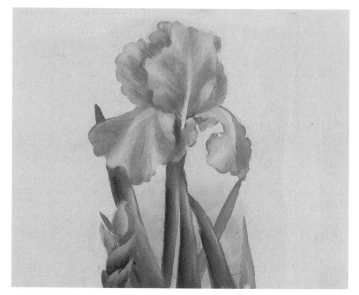

3. Iris: Shade as shown on the photo with a no. 8 shader and a side load of Lavender + a drop of Lilac Dusk. Let dry, then repeat for better coverage.

Streaked areas: Load a no. 6 filbert into Lavender + a drop of Lilac Dusk. Staying on the tip of the filbert, lightly pull streaks starting at the center vein line and going out toward the petal edges. Sparingly do this on the other petals (as shown) so as not to interfere with the light areas.

Leaves: Using a no. 10 shader, side load into Rain Forest Green and darken the lower background area behind leaves. This should be very transparent to give a misty look. Using a no. 8 or no. 10 shader, side load into a mix of Medium Foliage Green + Dark Foliage Green (2:1) for the front leaves, and a mix of Rainforest Green + Leprechaun (1:1) and Golden Brown + a dot of Lavender for bud leaves. Let dry, then repeat for better coverage.

4. Highlights: Using a no. 6 filbert loaded into a mix of Pale Lilac + a dot of Lilac Dusk, further highlight the small areas of the outside edges, pyramiding (see page 8) so both light and highlight values can still be seen. Repeat if needed.

Leaves: Using a no. 8 shader, side load into a mix of Light Foliage Green + Pale Yellow, then pyramid small areas of highlight on the front leaves only.

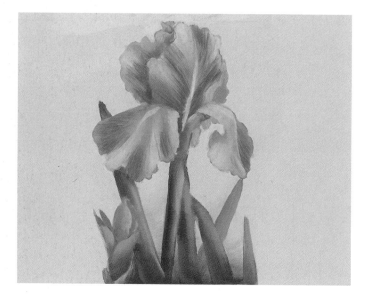

5. Shading: Using a no. 8 shader, side load the very dark areas using a mix of Lavender + Vintage Wine (2:1). With a no. 6 filbert, and the same color, streak darker areas using the pyramid system.

Leaves: Using a no. 8 shader, side load into a mix of Medium Foliage Green + Dark Foliage Green (1:1) + a smidgen of Vintage Wine on the front leaves and buds, pyramiding darker areas.

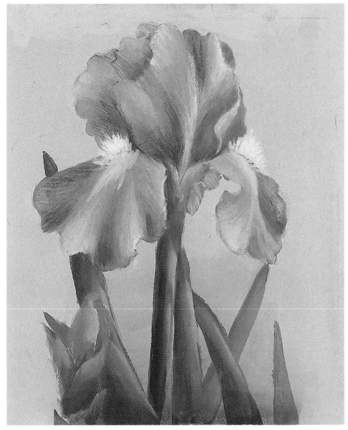

6. Lay your tracing back over the design and check petal separations and outside ruffle edges. Re-trace any mishaps and add more lights or darks as appropriate. Further lighten ruffled light edges with a side load of Light Ivory within very small areas. Using a no. 10/0 script, load the brush into an inky consistency of Pale Yellow + Light Ivory. Starting at the petal edge, pull upward to the beard lines in a fan shape. Using the no. 10/0 script liner and Light Ivory, stroke in several little lines to form the beard. Add Light Ivory lines in the center of the beard. If the streaking of lights and darks are too harsh, use the no. 6 filbert loaded with Lilac and lightly stroke over the base color areas, letting some blend into the edges of the lights and darks. Study the photos to see if anything is missing.

Leaves: Using a no. 10 shader, side load into Rain Forest Green and lighten the left side (dark side) of the front leaves.

Varnish with a 1-inch (25mm) wash brush and Delta Matte Varnish.

Iris pattern

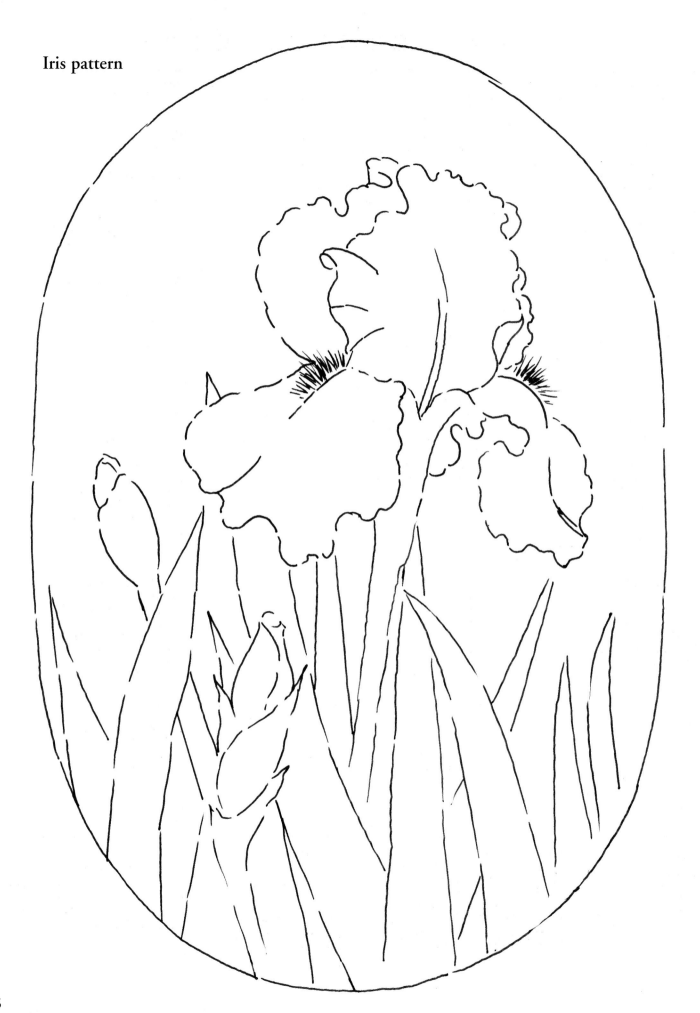